PHYSICAL REMAINS

Twenty Suggested Histories

by

Simon Cardew

FIRST EDITION
2015

*Do objects hold their own meanings,
or only meanings we impose upon them?*

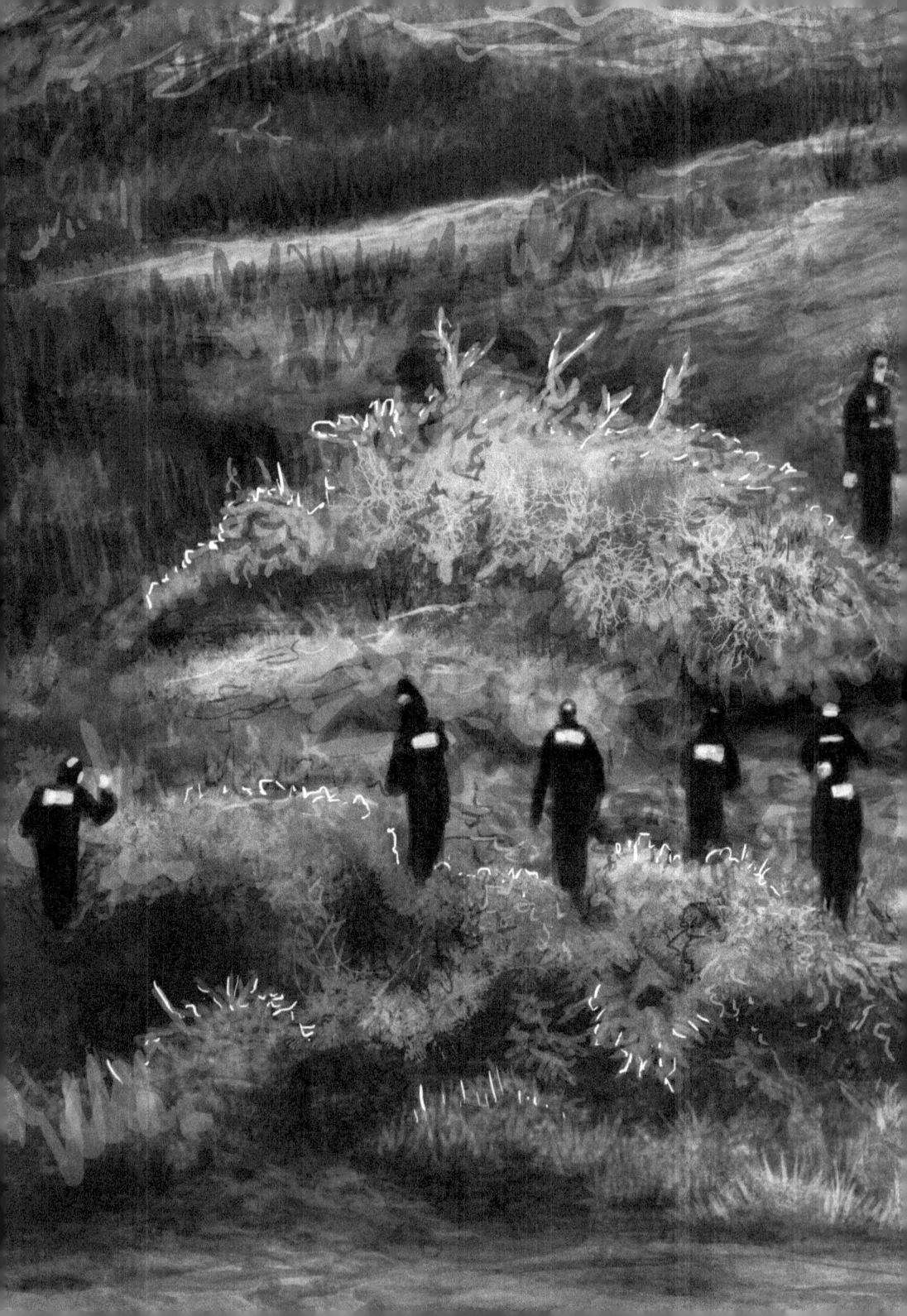

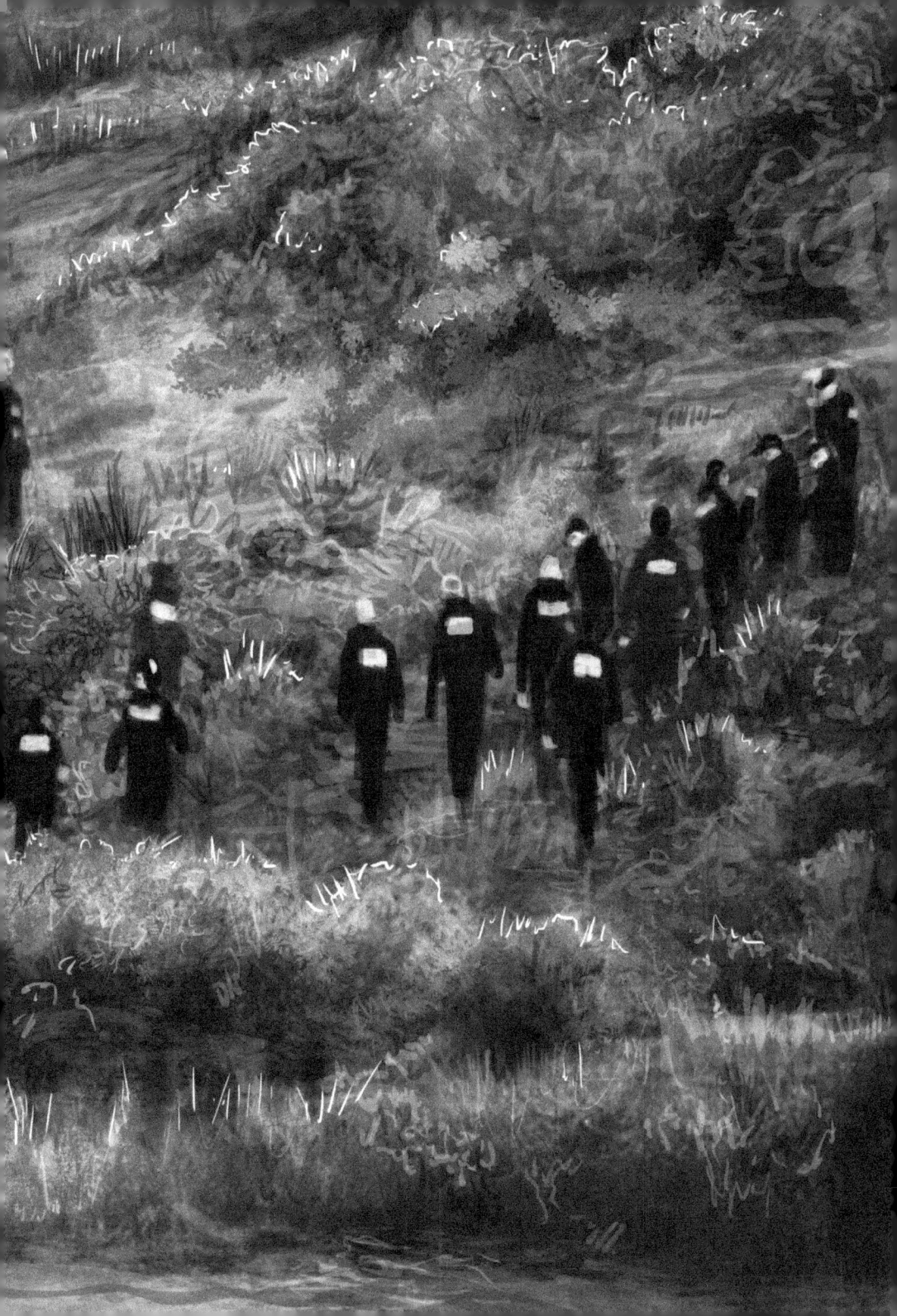

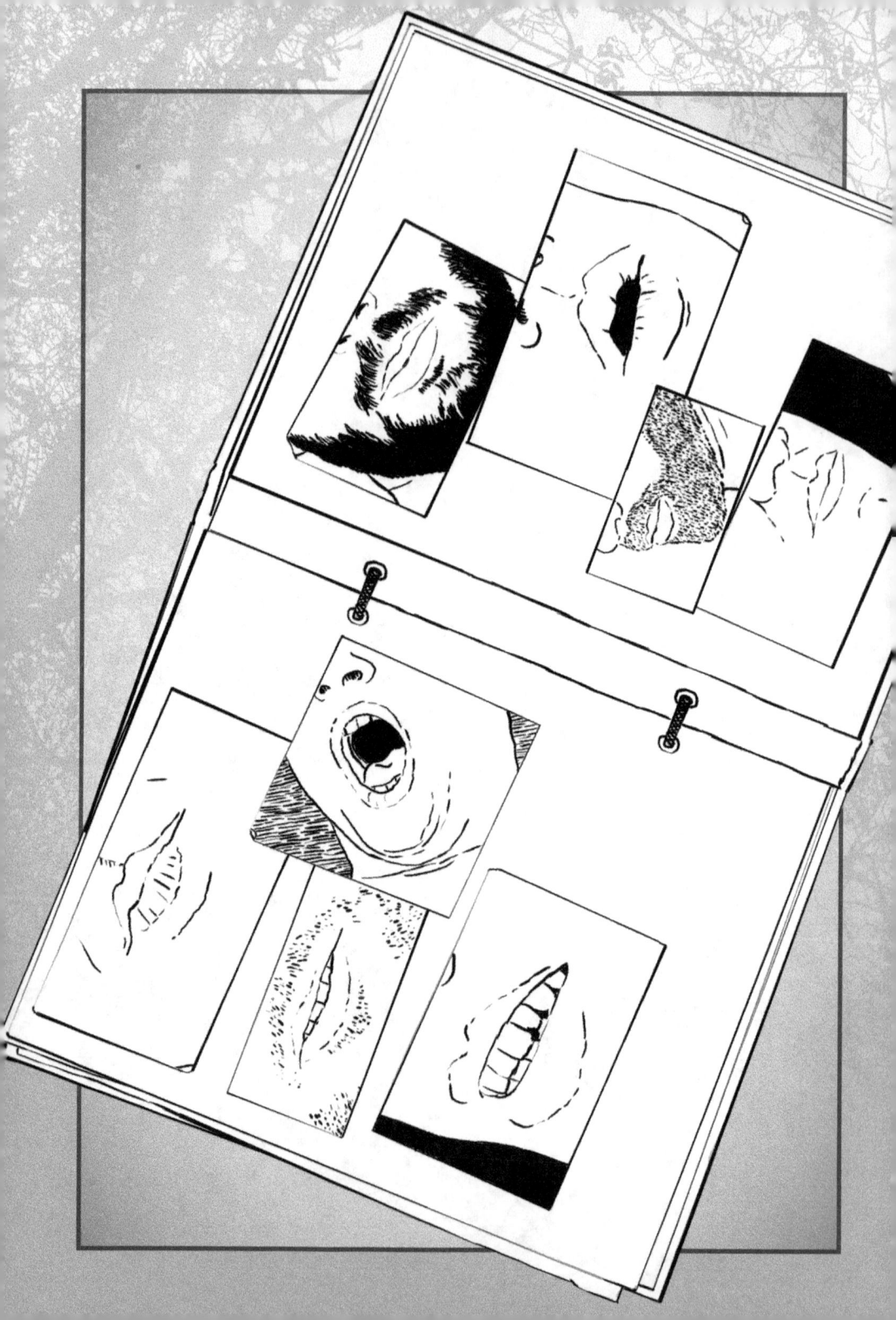

A SCRAPBOOK FILLED WITH IMAGES OF YOUNG MEN'S MOUTHS CUT FROM PORNOGRAPHIC MAGAZINES

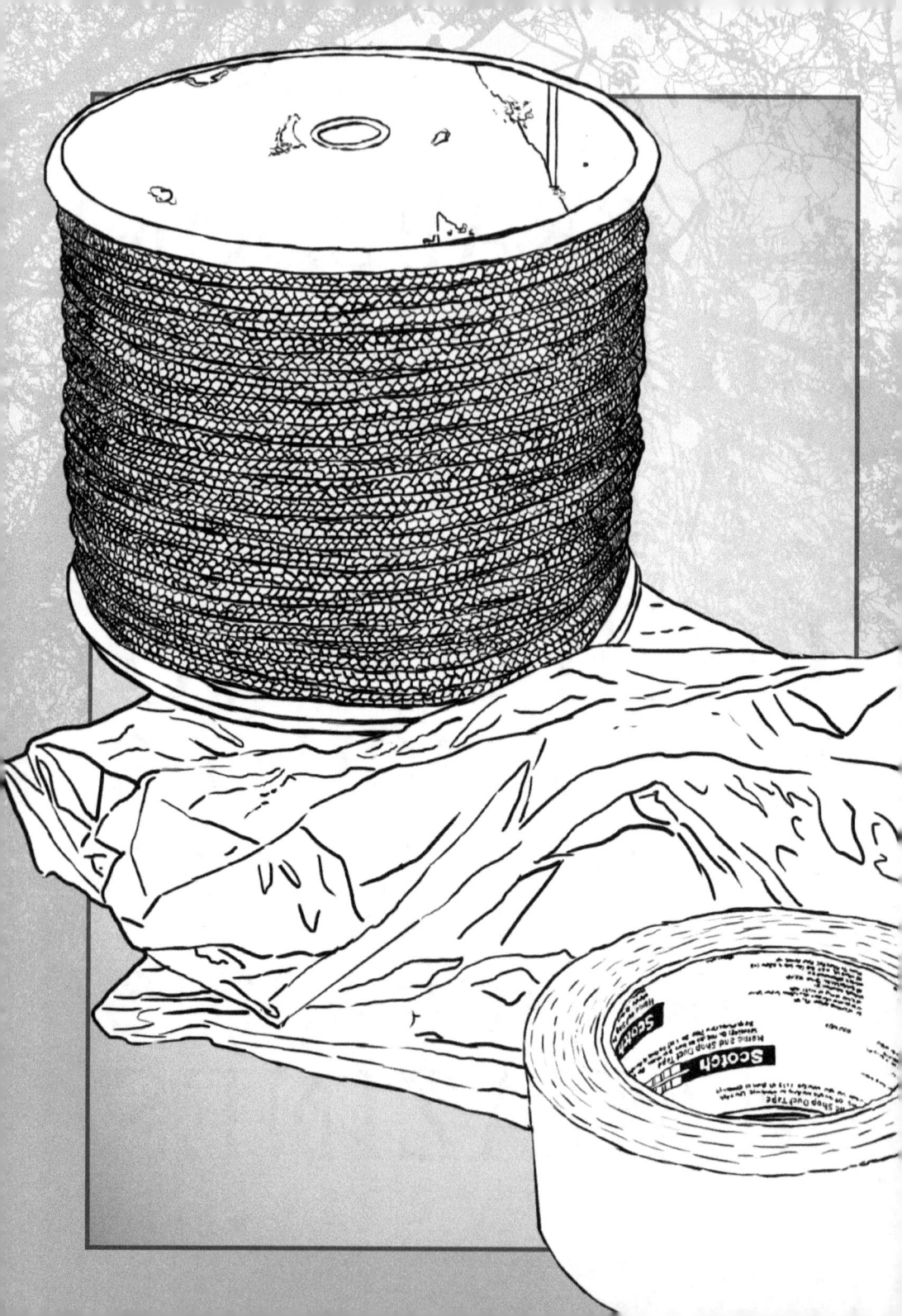

A ROLL OF DUCT TAPE, A LARGE BLACK PLASTIC BAG, ONE HUNDRED METRES OF PARACHUTE CORD

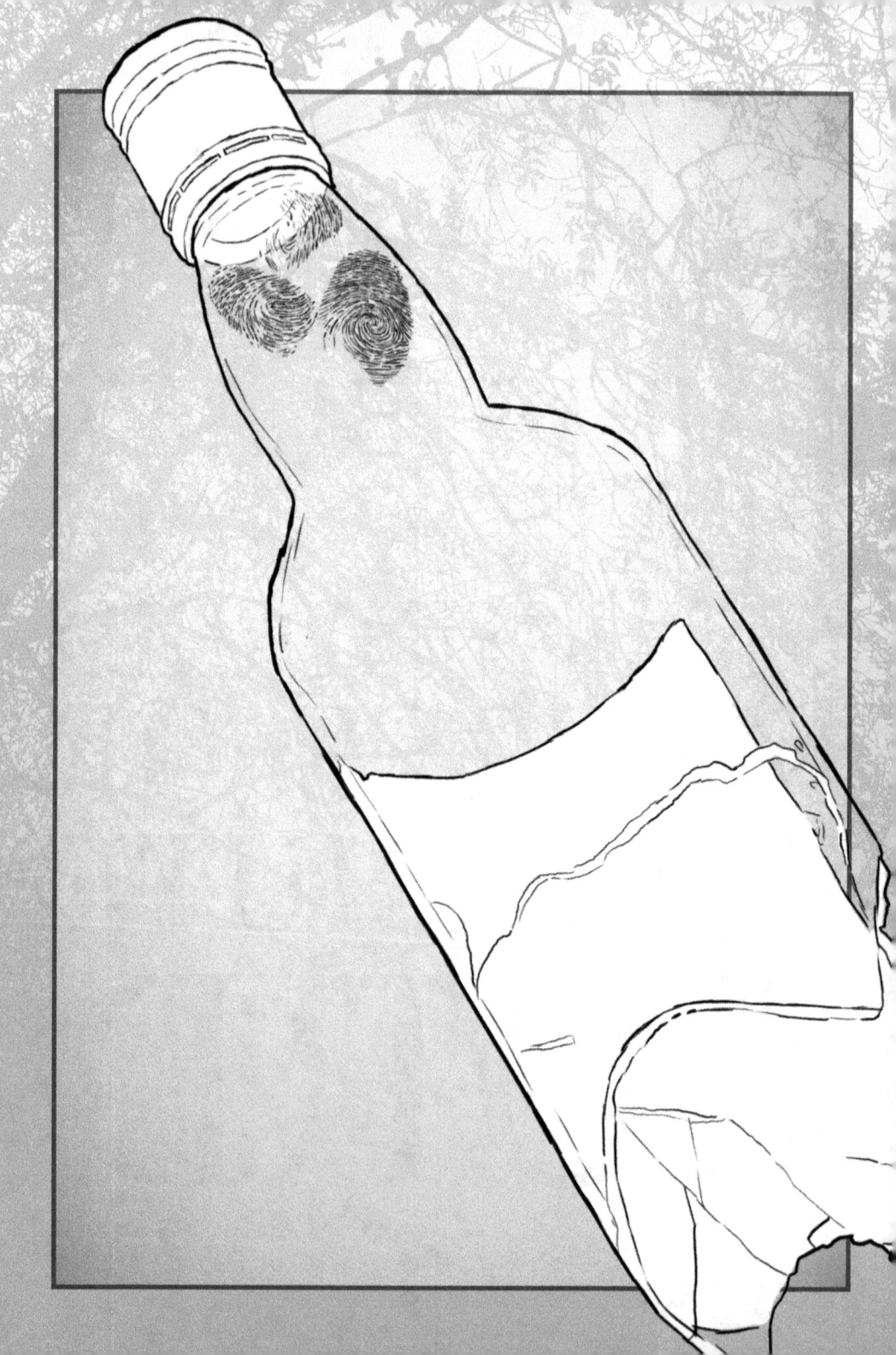

TWO SETS OF FINGERPRINTS ON THE NECK OF A BROKEN VODKA BOTTLE

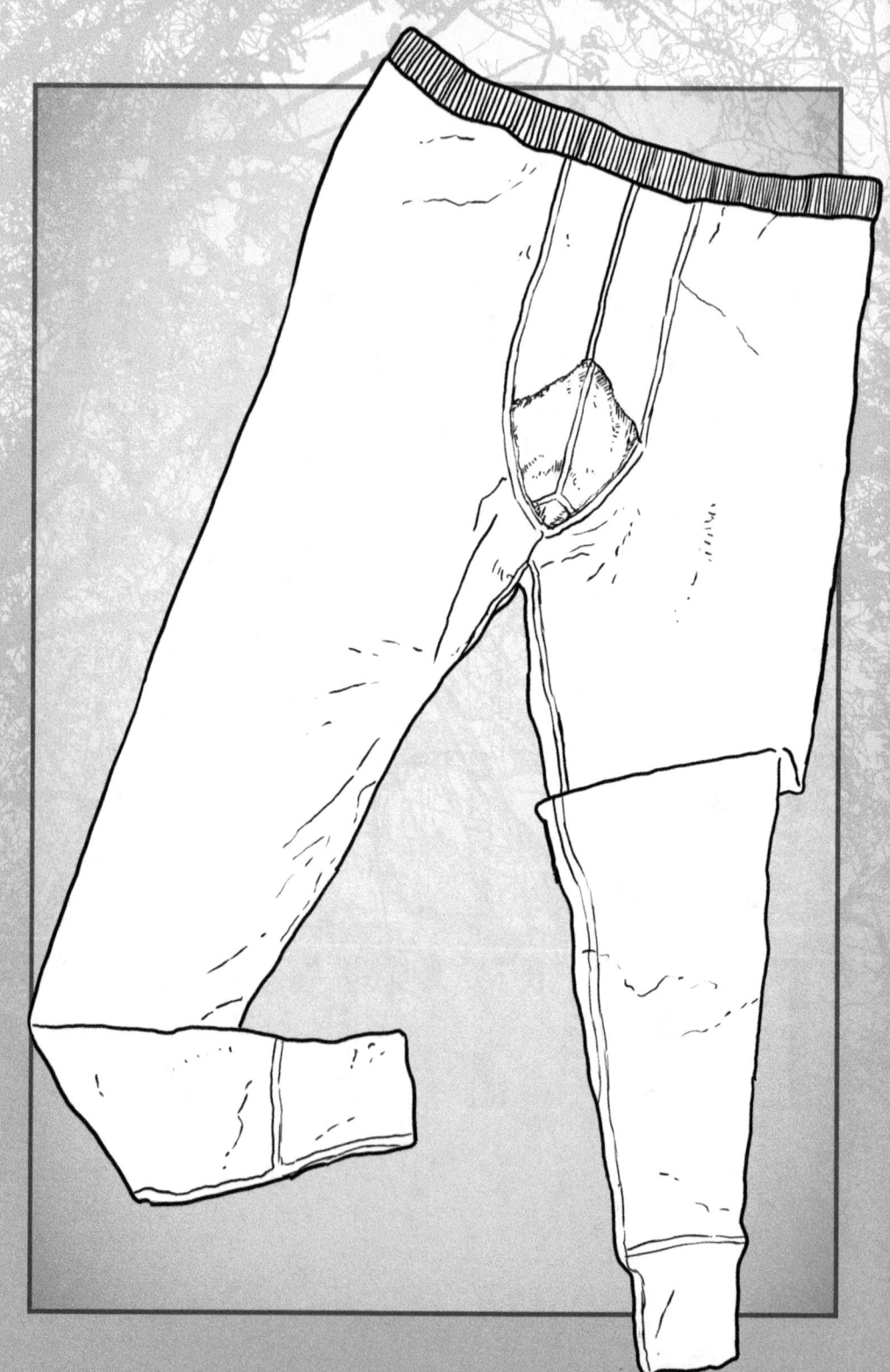

A SET OF THERMAL LEGGINGS WITH THE CROTCH CAREFULLY CUT OUT

A SIX FOOT WOODEN STAKE WITH TWO CRUDELY FASHIONED POINTS

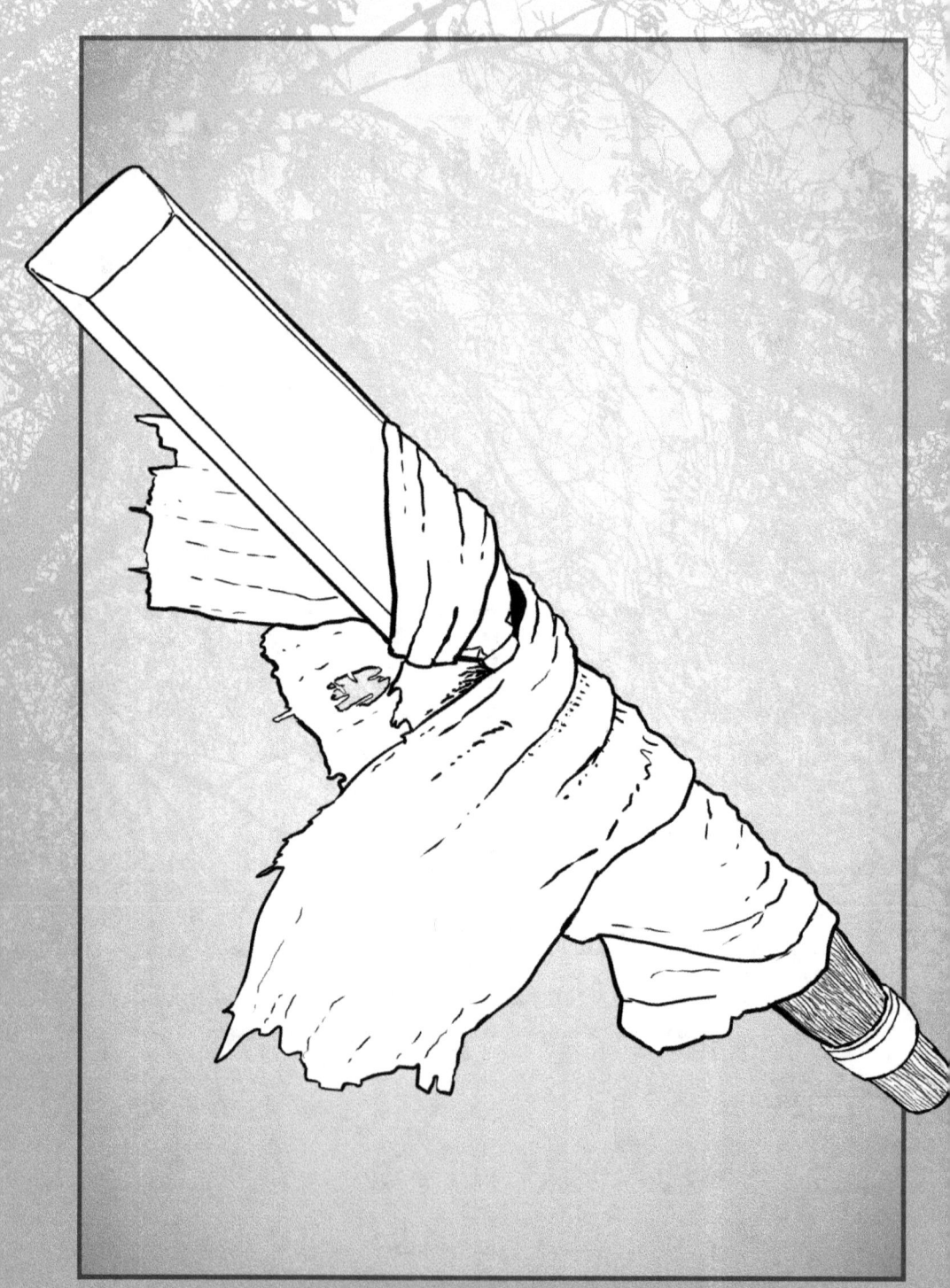

A NEWLY SHARPENED CHISEL WRAPPED IN DIRTY CLOTH ON THE FRONT SEAT OF A BATTERED WHITE VAN

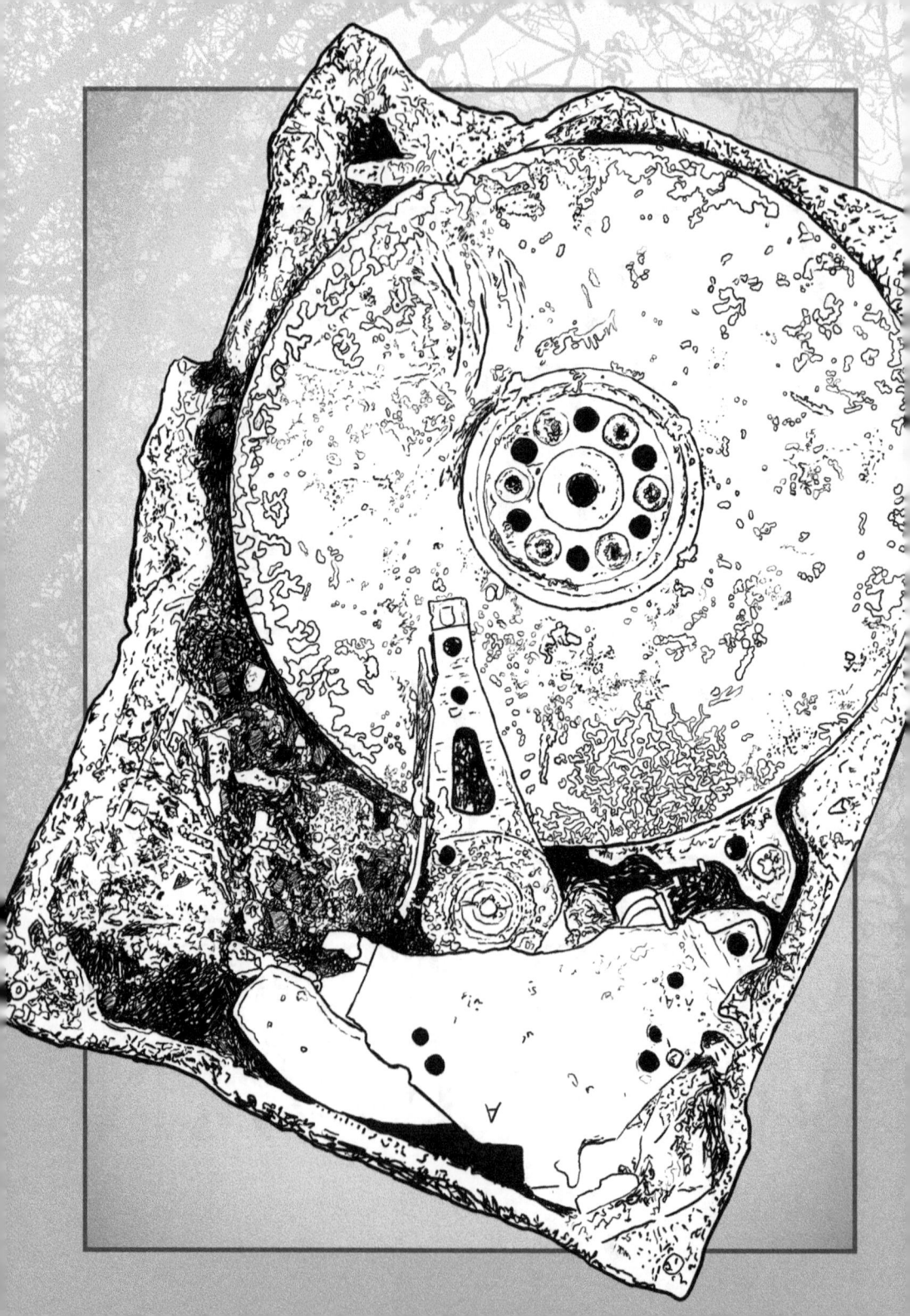

THE CHARRED REMNANTS OF A LARGE EXTERNAL HARD DRIVE SMOULDERING IN THE FIREPLACE OF A SUBURBAN RESIDENCE

A SINGLE DISCOLOURED PAVING SLAB, CARELESSLY RE-LAID THE WRONG WAY UP

A LENGTH OF ELECTRICAL CABLE TIED INTO AN APPROXIMATION OF A NOOSE

FIVE SPENT SHOTGUN CARTRIDGES LYING IN THE BED OF A NARROW STREAM

A SEALED BLUE PLASTIC DRUM WASHED IN ON THE MORNING TIDE

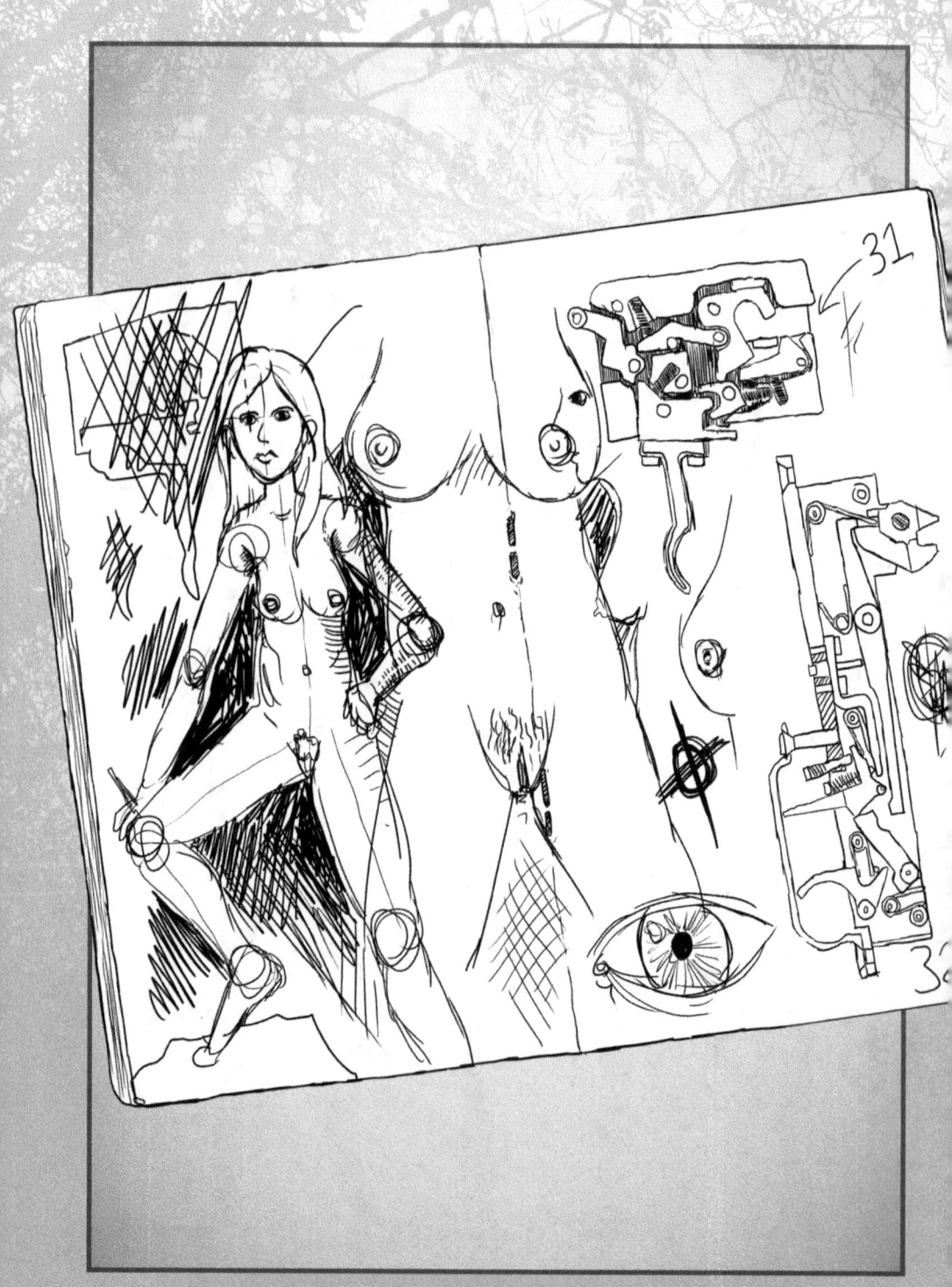

A NOTEPAD CONTAINING INTRICATE NAIVE DRAWINGS OF NUDE WOMEN AND CROSSBOW MECHANISMS

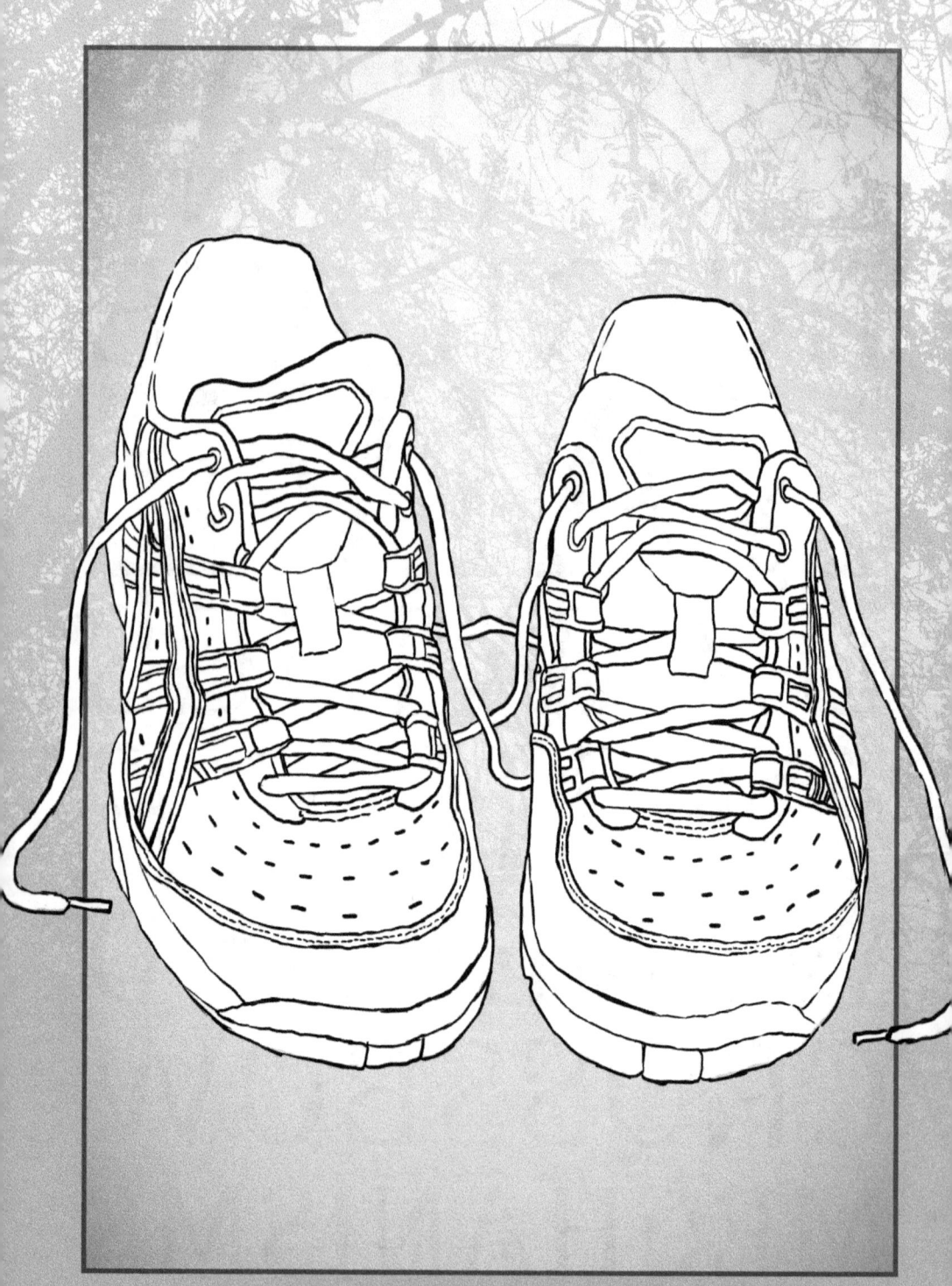

A PAIR OF PINK TENNIS SHOES NEATLY ARRANGED ON THE PARAPET OF A RAILWAY BRIDGE

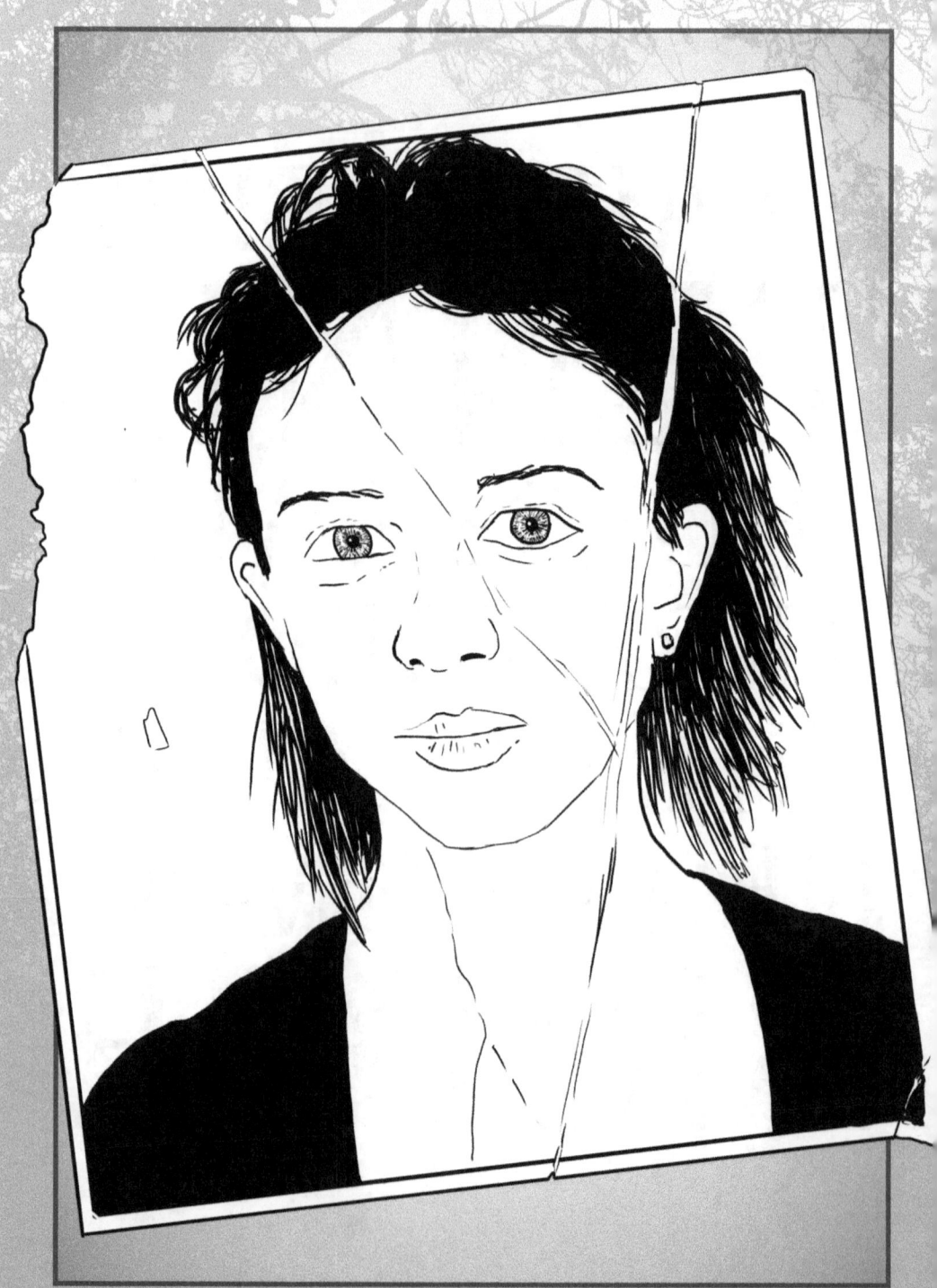

A PHOTOGRAPH OF A DEAD PROSTITUTE TAKEN FROM THE LOCAL NEWSPAPER

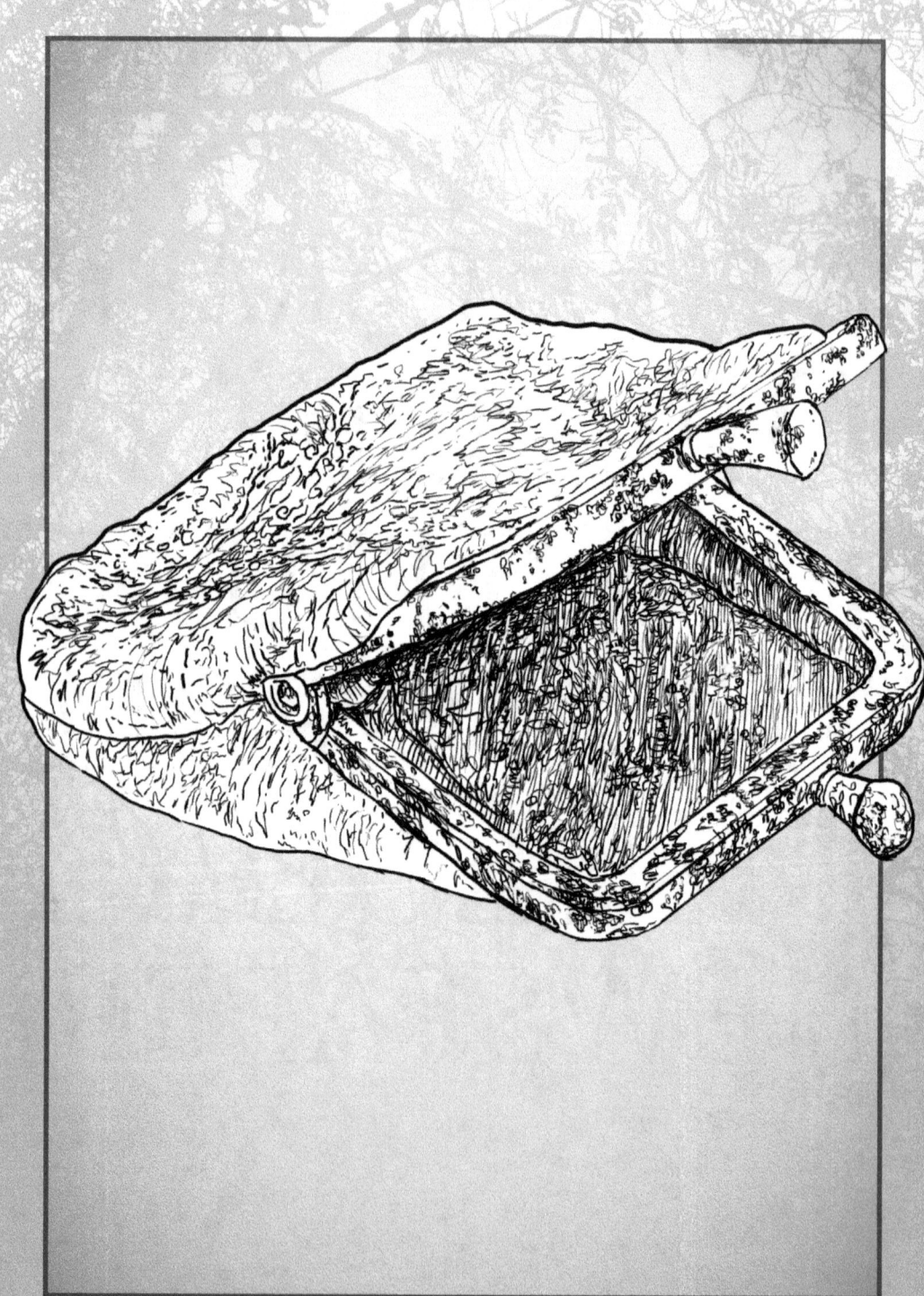

AN EMPTY PURSE FOUND RUSTING IN A HOLLOW ON THE MOOR

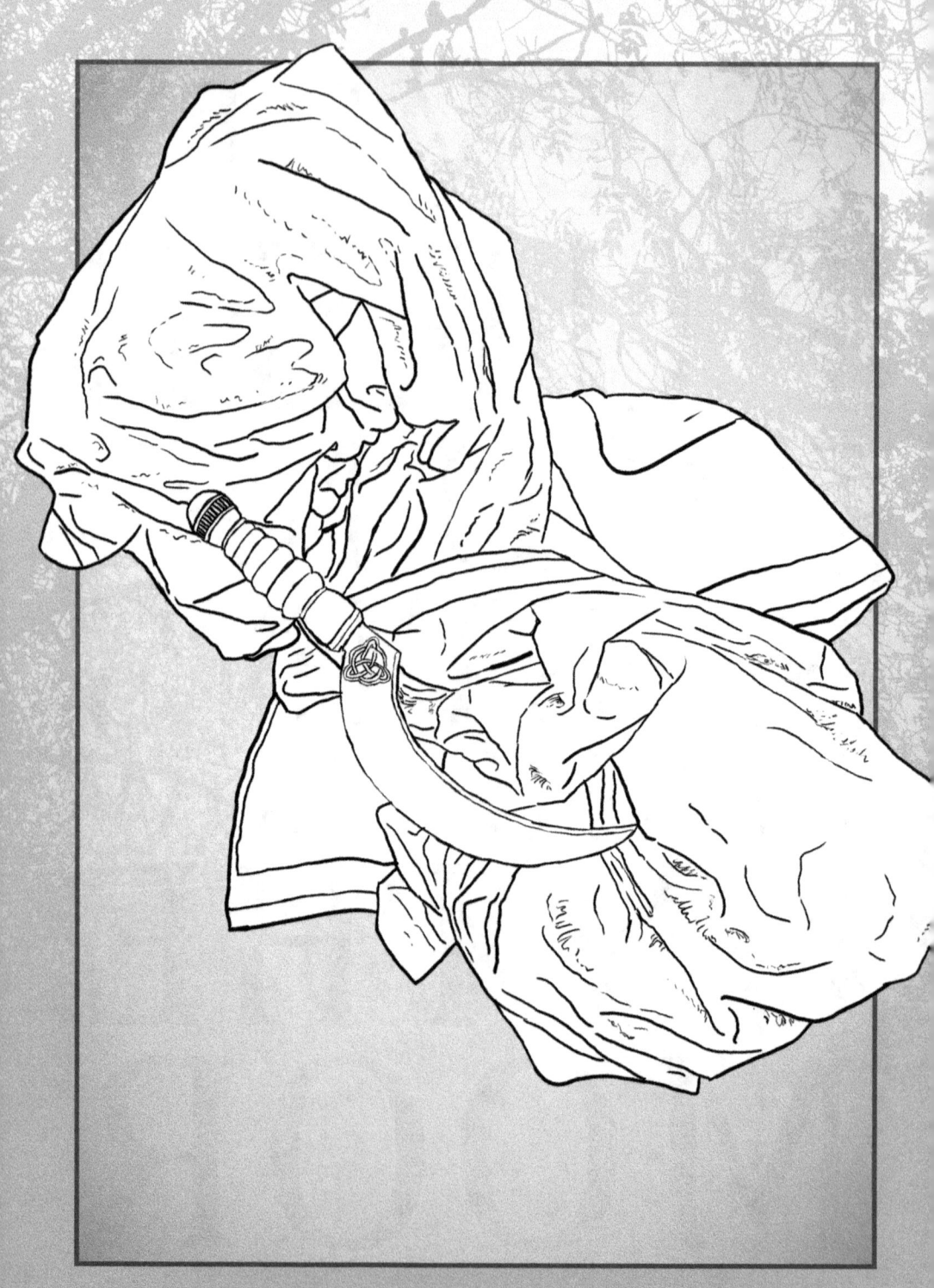

A SET OF HOODED ROBES AND A LARGE ORNATE CURVED DAGGER

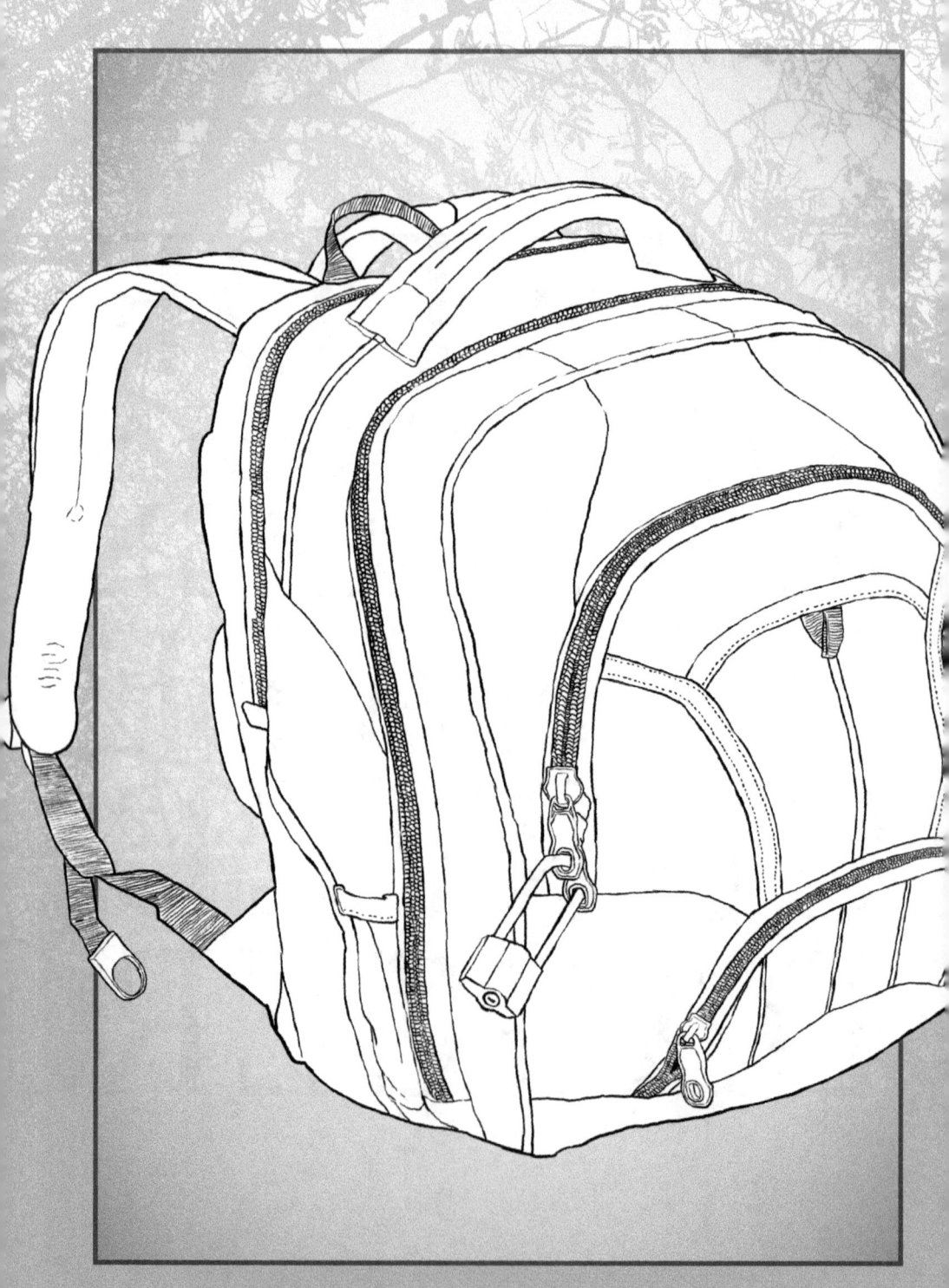

A LOCKED BACKPACK, ABANDONED ON A BENCH AT A BUSY RAILWAY STATION

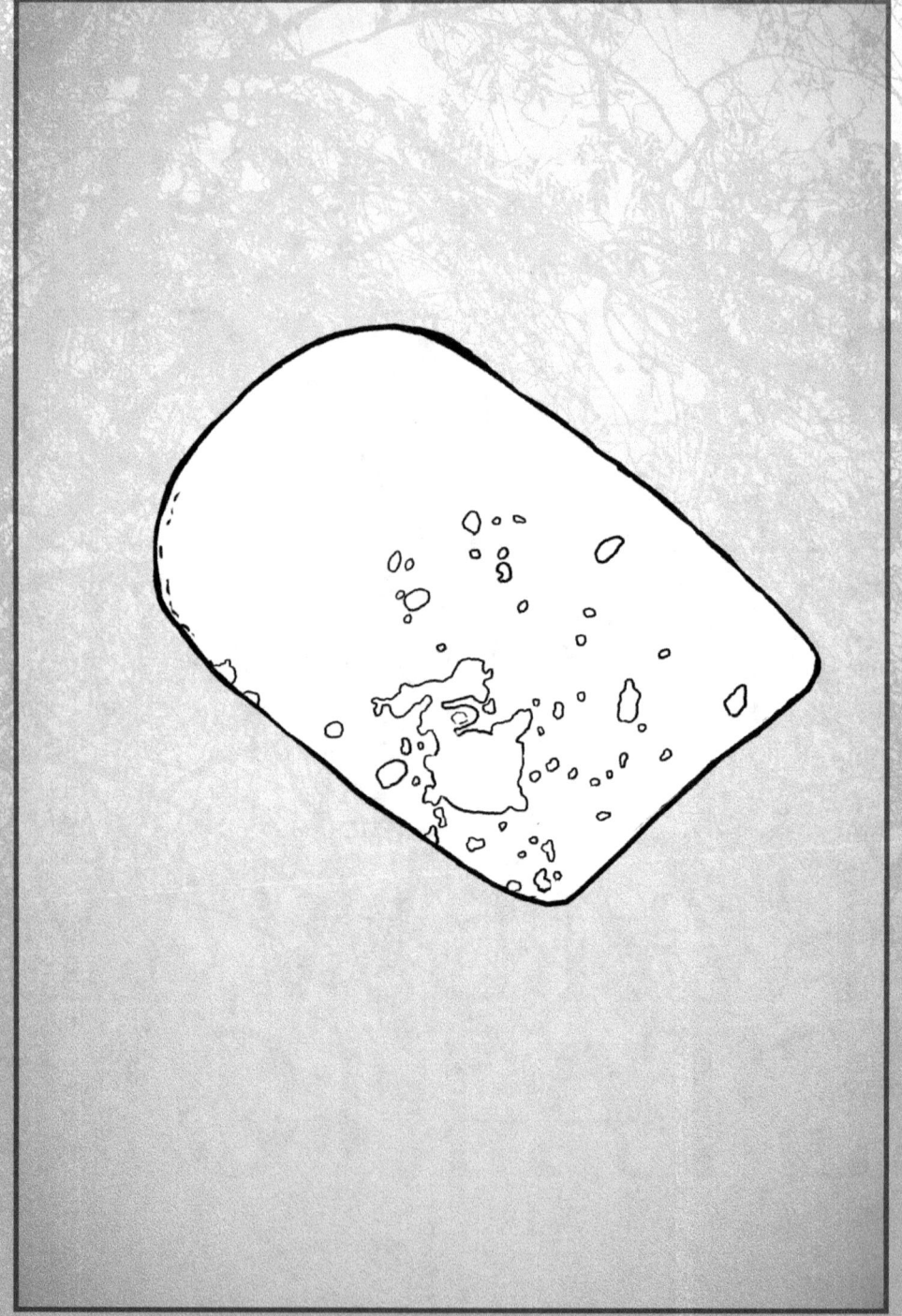

SPOTS OF HUMAN BLOOD ON AN ELECTRIC BLUE FALSE FINGERNAIL

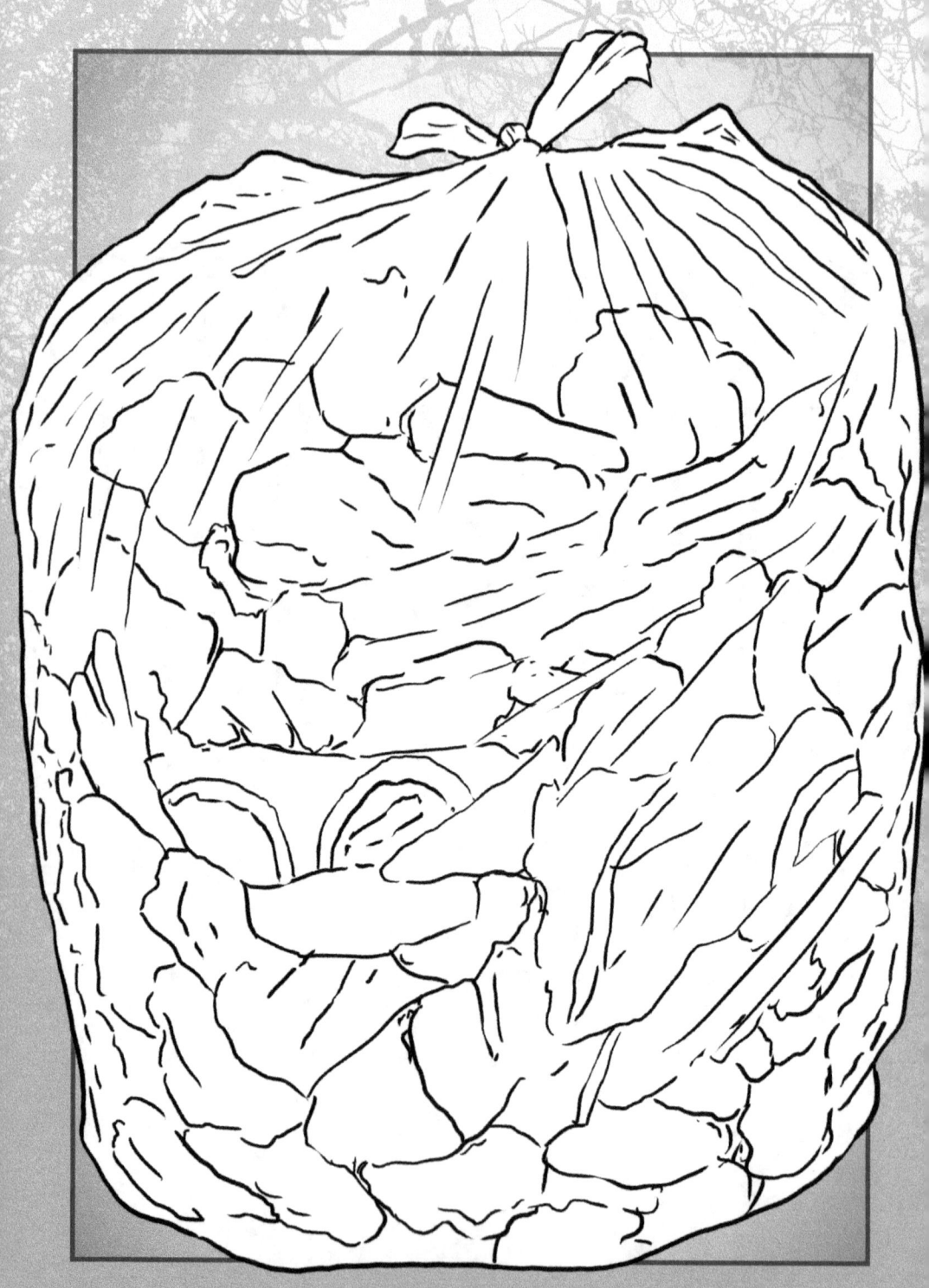

A LARGE BAG FULL OF CHILDREN'S UNDERWEAR IN VARIOUS COLOURS AND SIZES

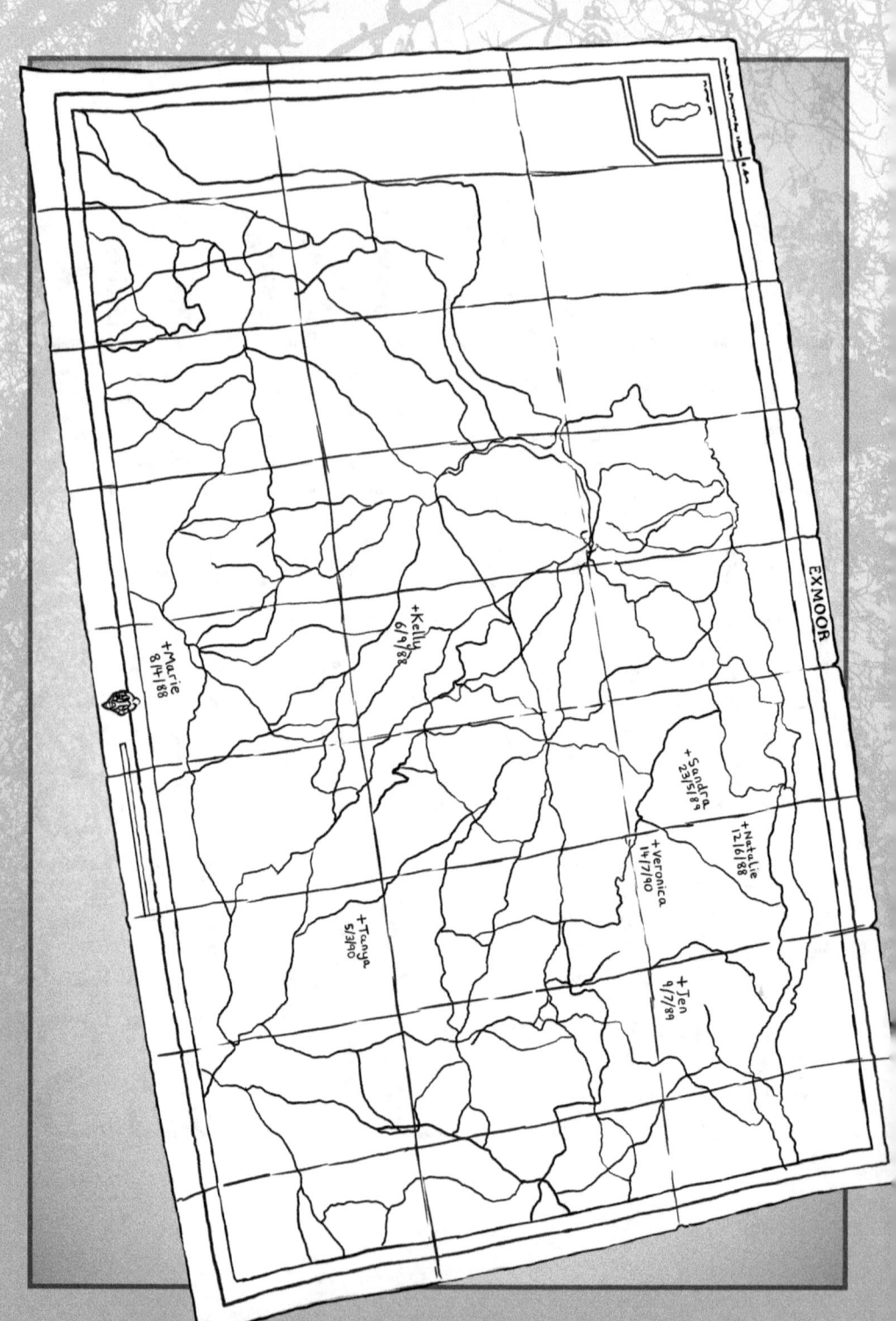

A HIKING MAP OF A NATIONAL PARK MARKED WITH DATES AND WOMEN'S NAMES

"Five weeks later, all nine children were sent home on the orders of a mainland sheriff. The seized objects were also returned. They included a video of the TV comedy show 'Blackadder', a novel by the detective writer Ngaio Marsh, and a model aeroplane made by a boy out of two pieces of wood, catalogued as 'one wooden cross'. The minister was asked to sign for the return of 'three masks, two hoods, one black cloak', but refused to sign until the inventory was altered to 'three nativity masks, two academic hoods, one priest's robe'."

Donald Rooum, "Satanic Child Abuse Hysteria in Britain 1990-1991" published in *Ethical Record,* April 1998 & May 1998

www.ingramcontent.com/pod-product-compliance
Lightning Source LLC
Chambersburg PA
CBHW072256170526
45158CB00003BA/1087